Cute Dog Grayscale

coloring book for adults relaxation

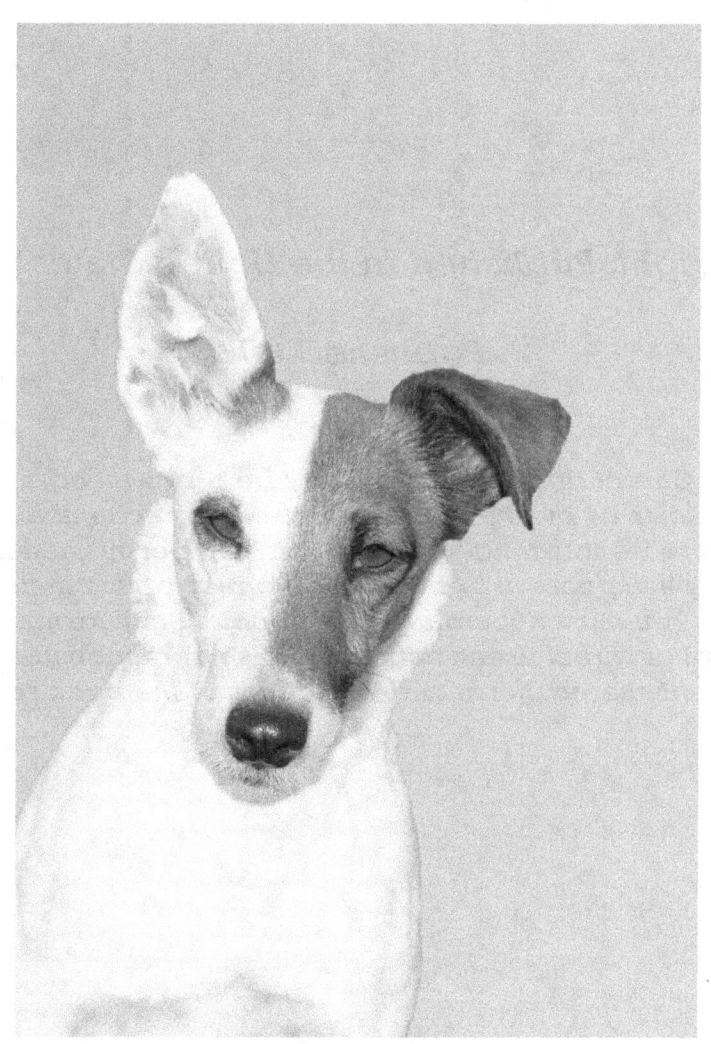

New way to color with Grayscale coloring book

Copyright: Published in the United States by V Art

Published 2017

All rights reserved. No part of this publication may be reproduced, stored in retrieval system, copied in any form or by any means, electronic, mechanical, photocopying, recording or otherwise transmitted without written permission from the publisher. Please do not participate in or encourage piracy of this material in any way. You must not circulate this book in any format.
V Art does not control or direct users' actions and is not responsible for the information or content shared, harm and/or actions of the book readers.

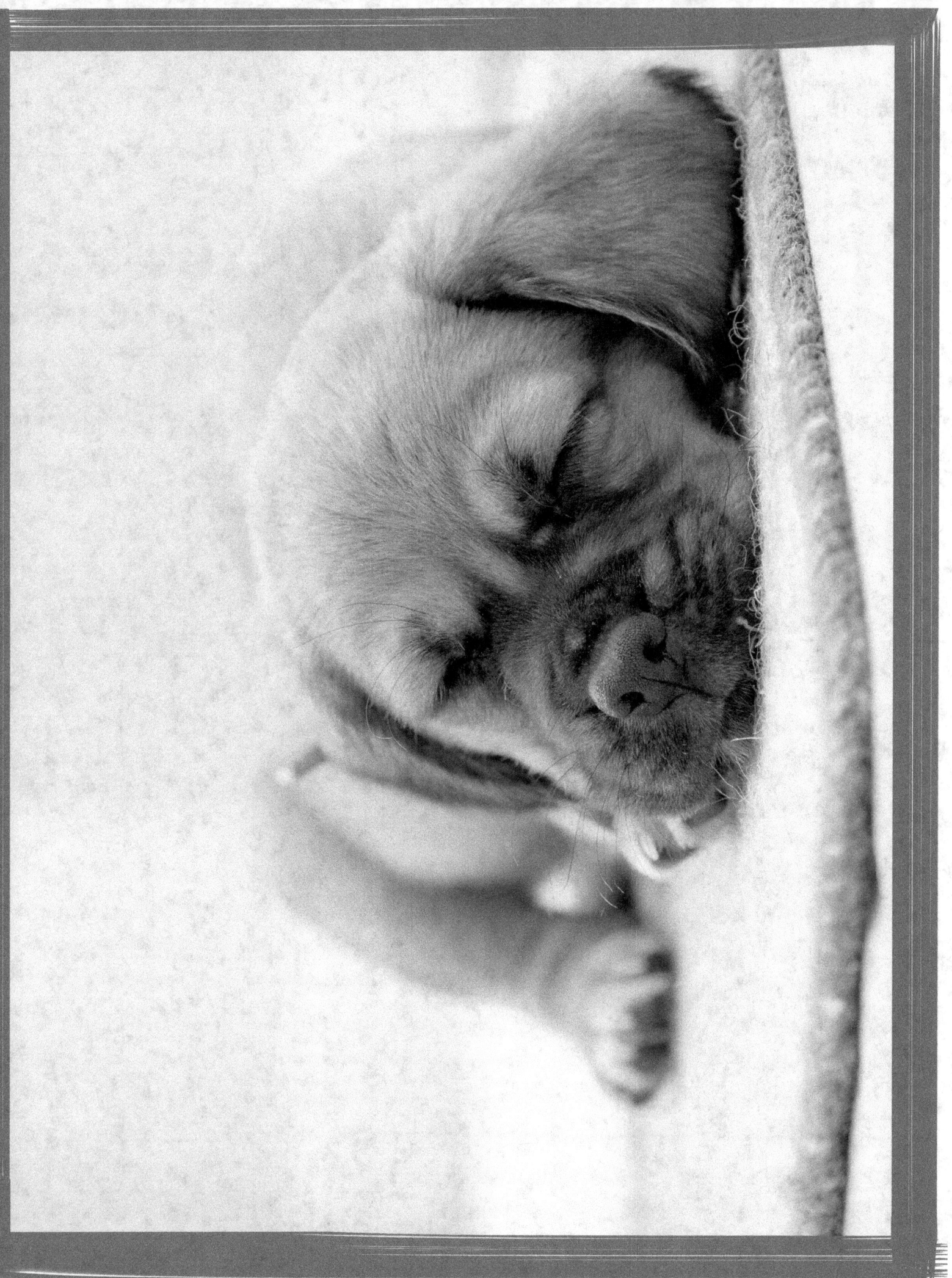

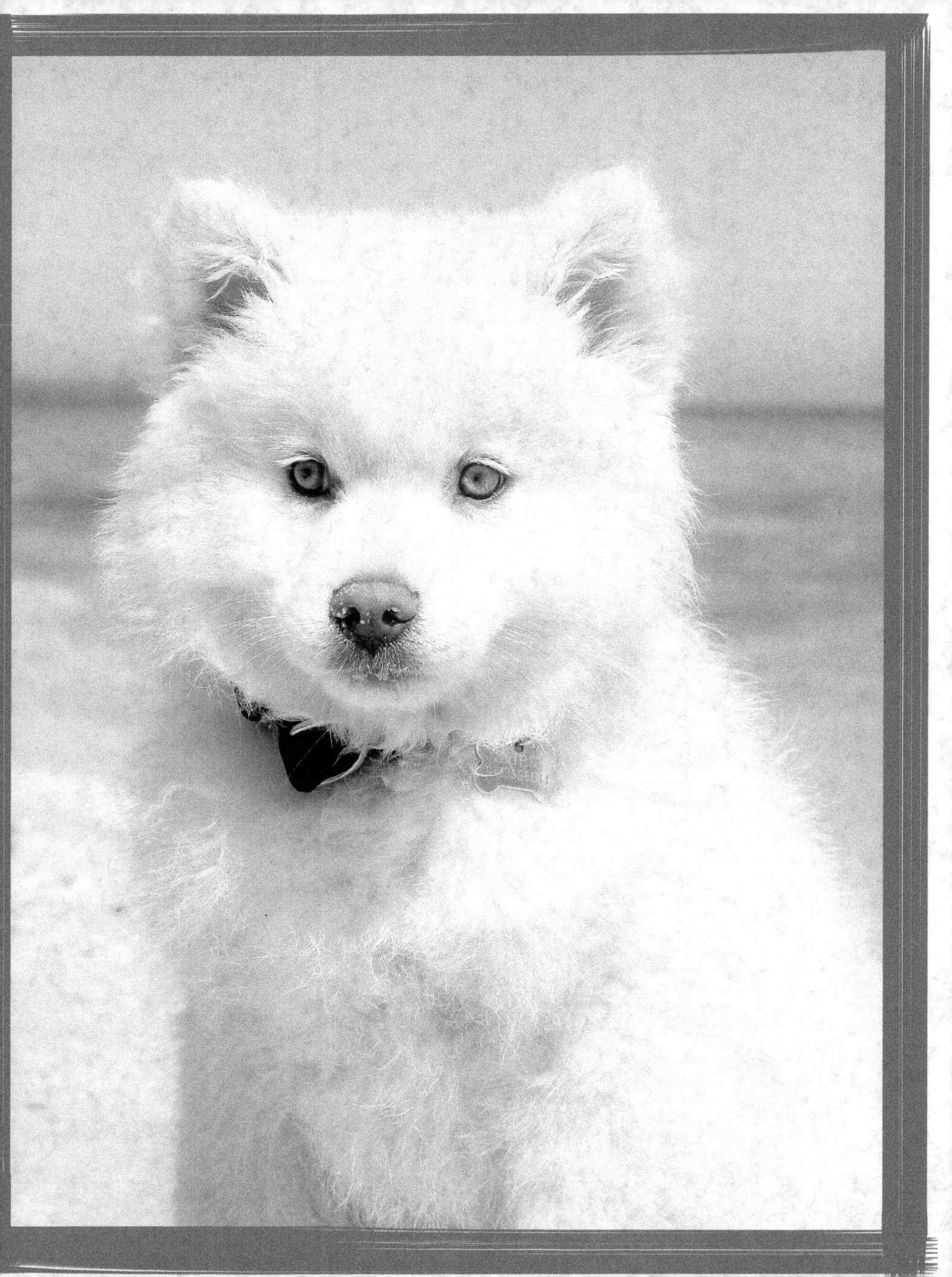

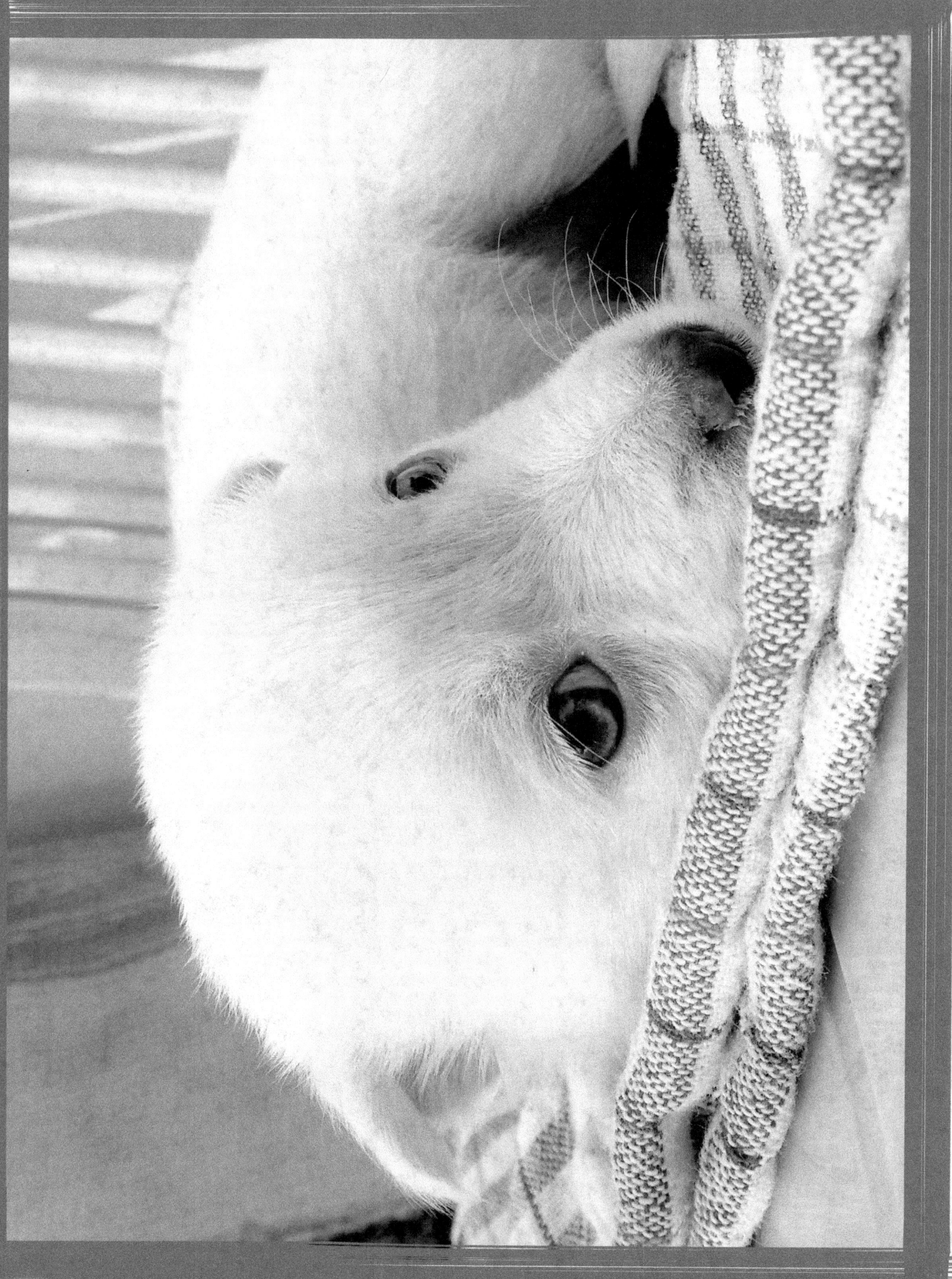

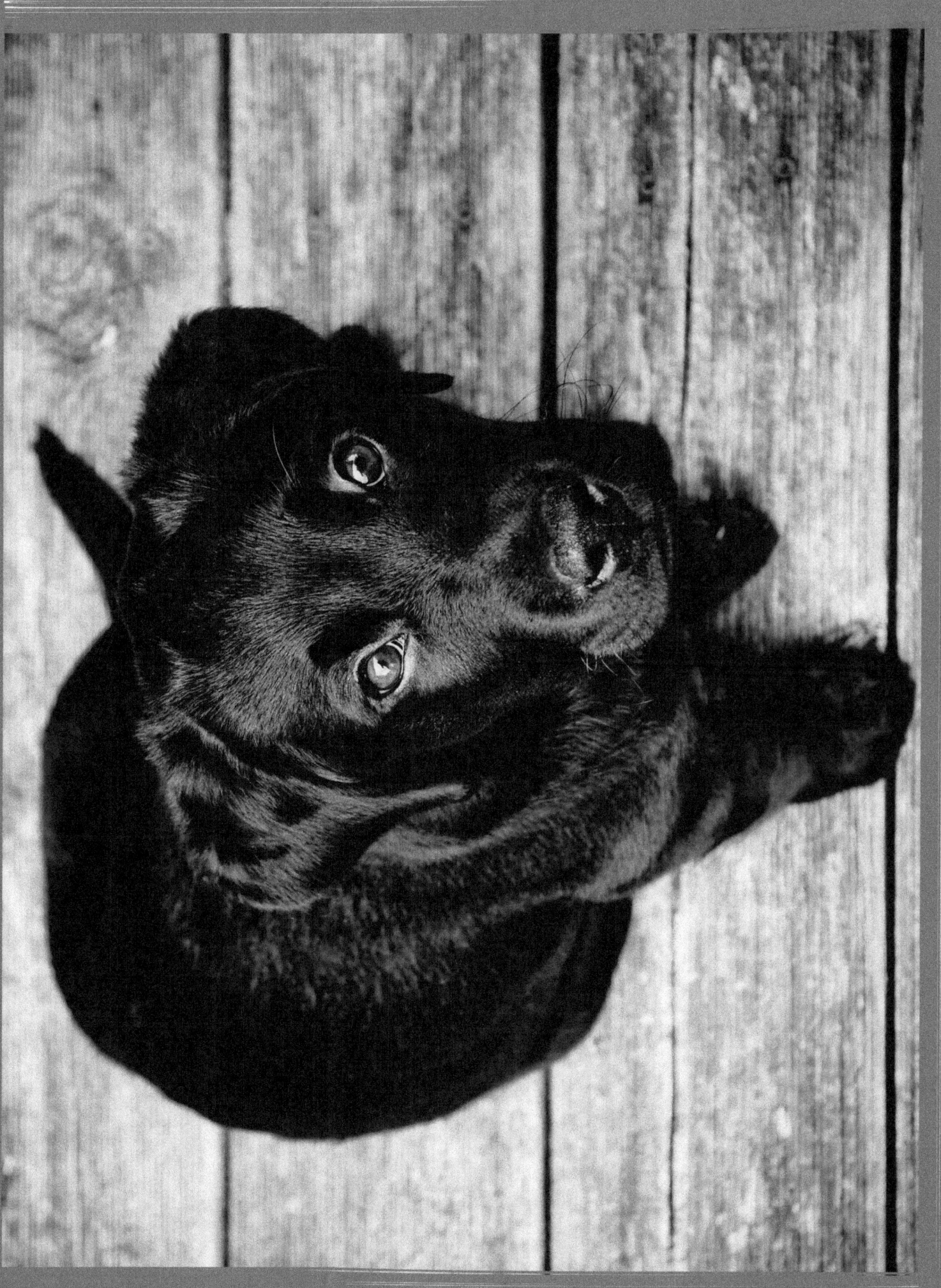

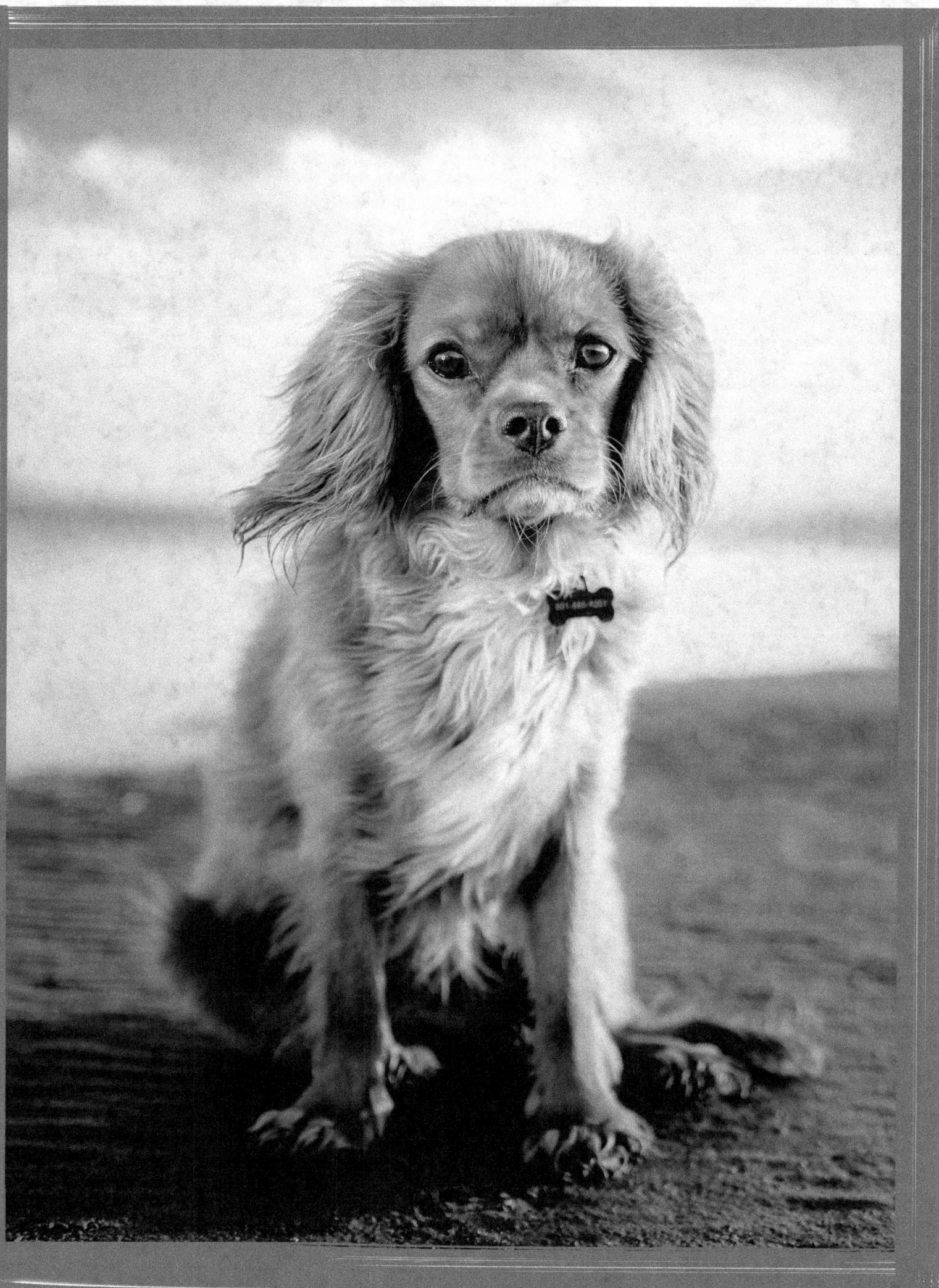

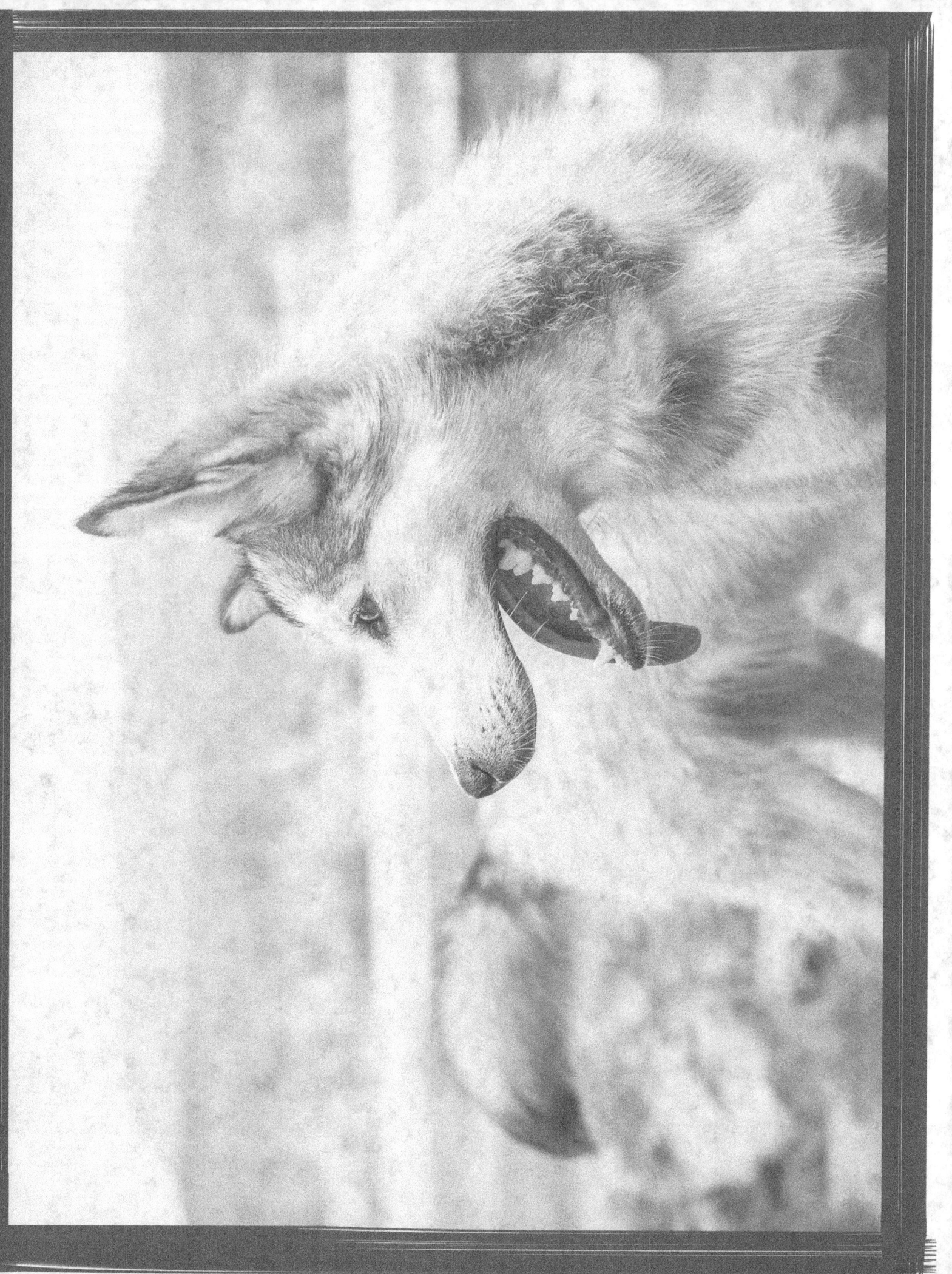

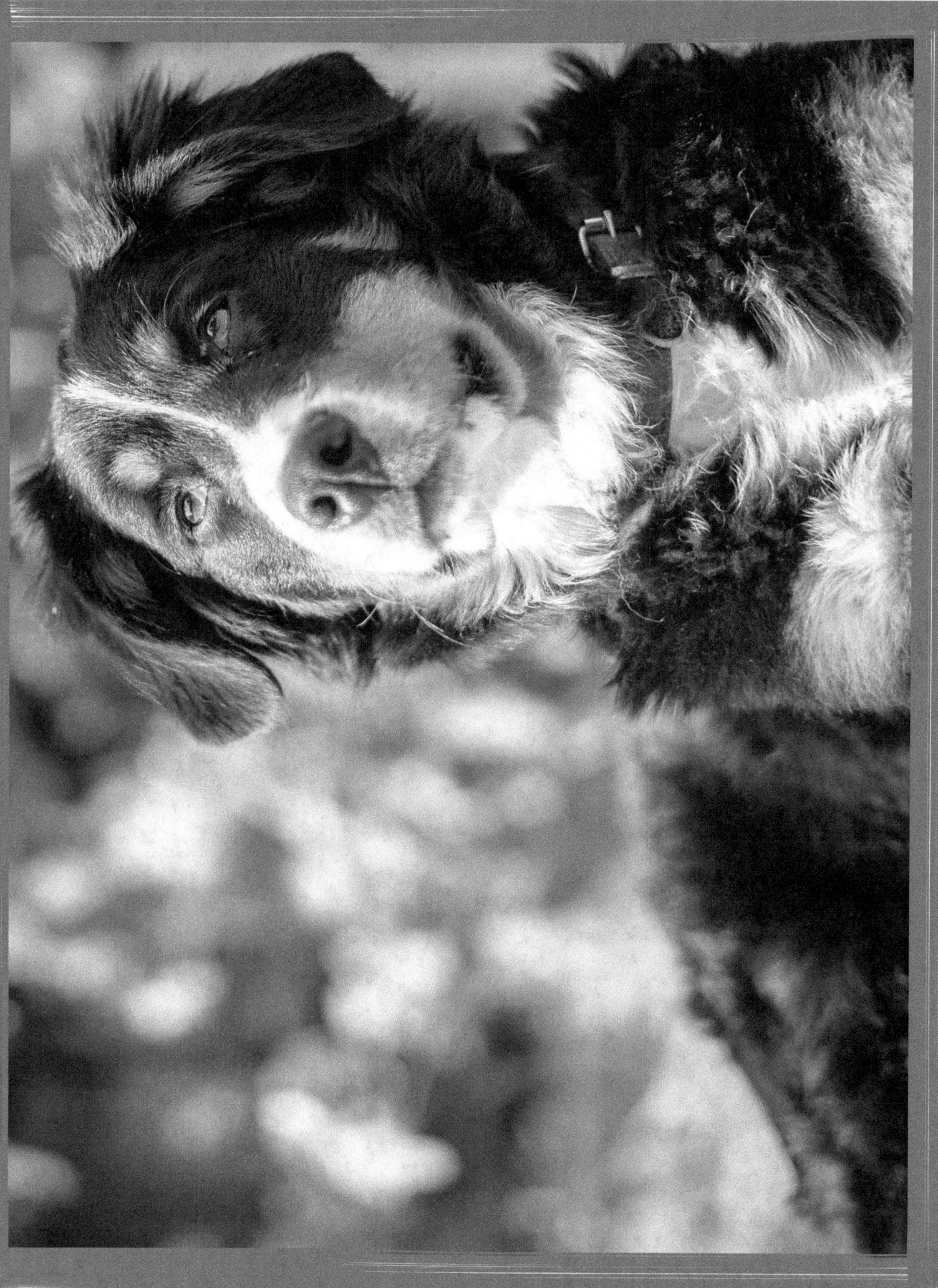

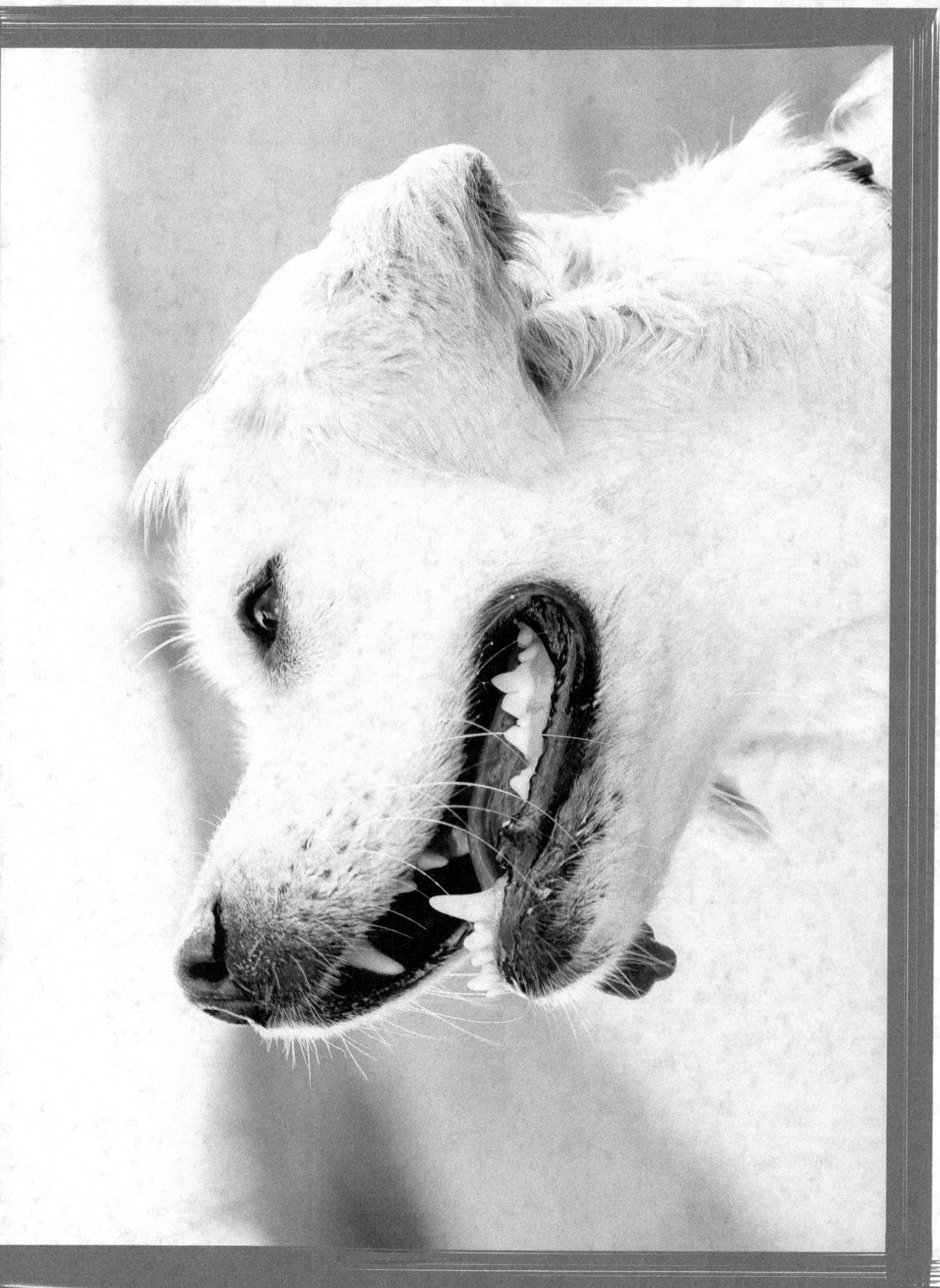

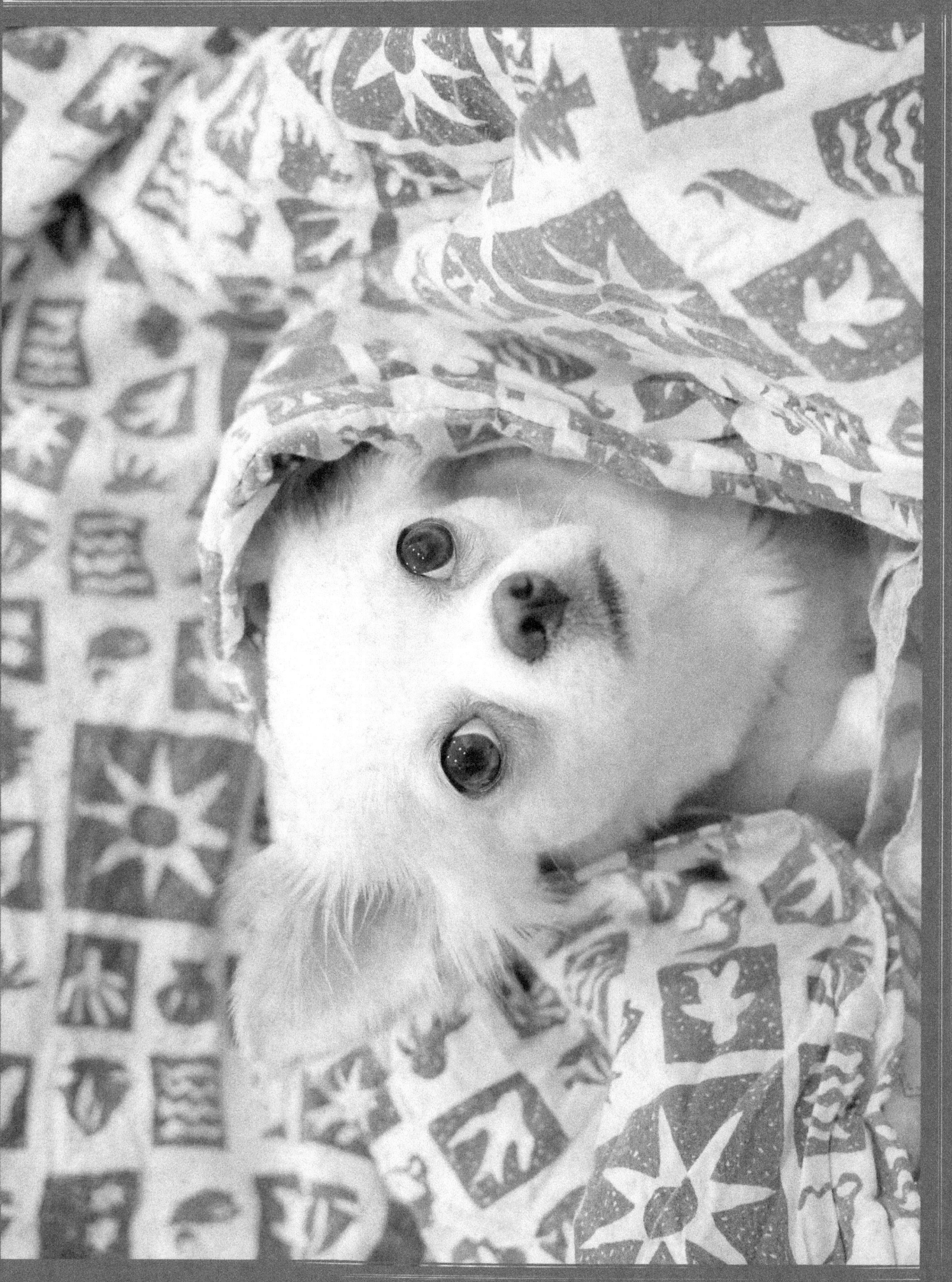

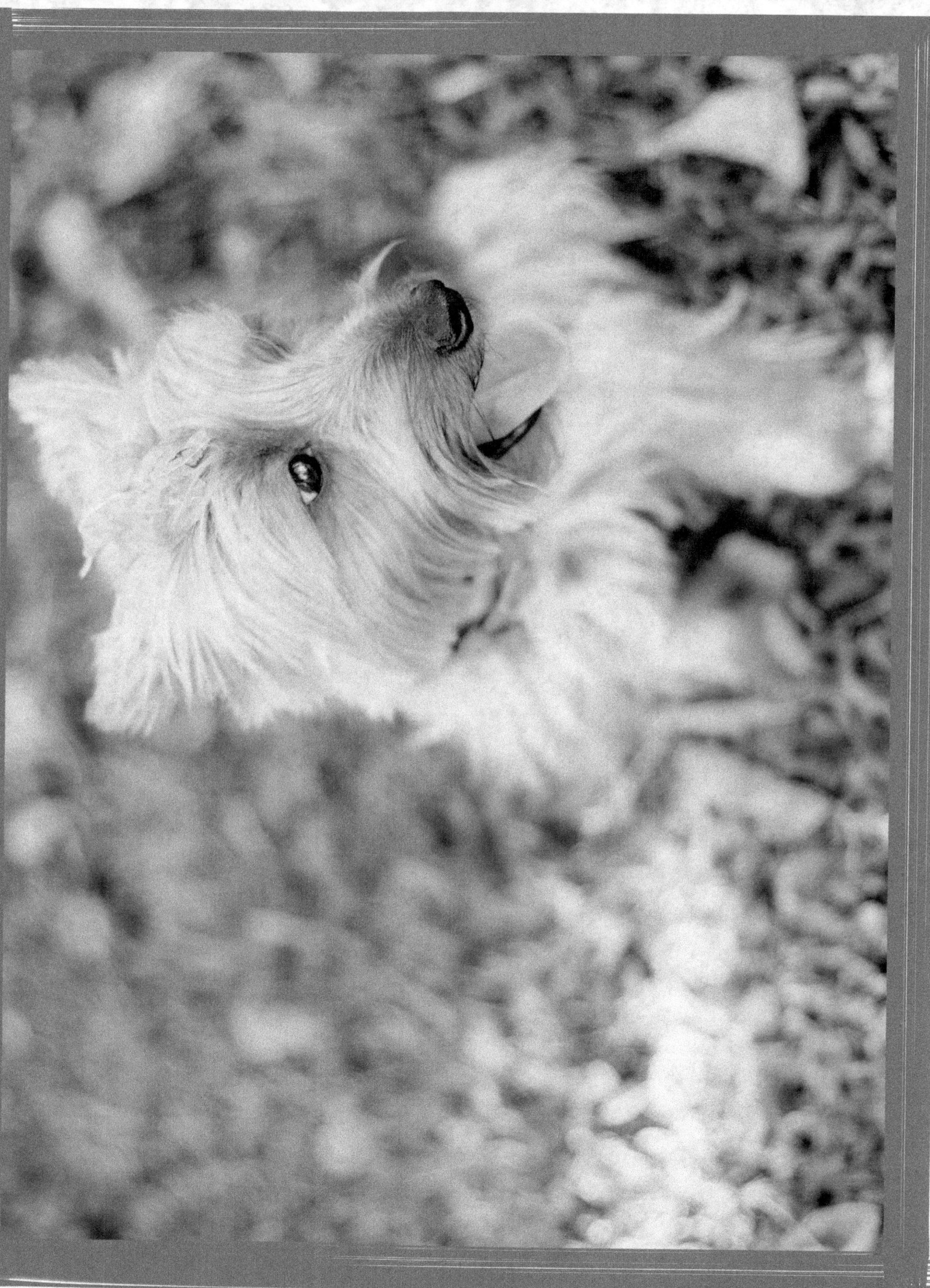

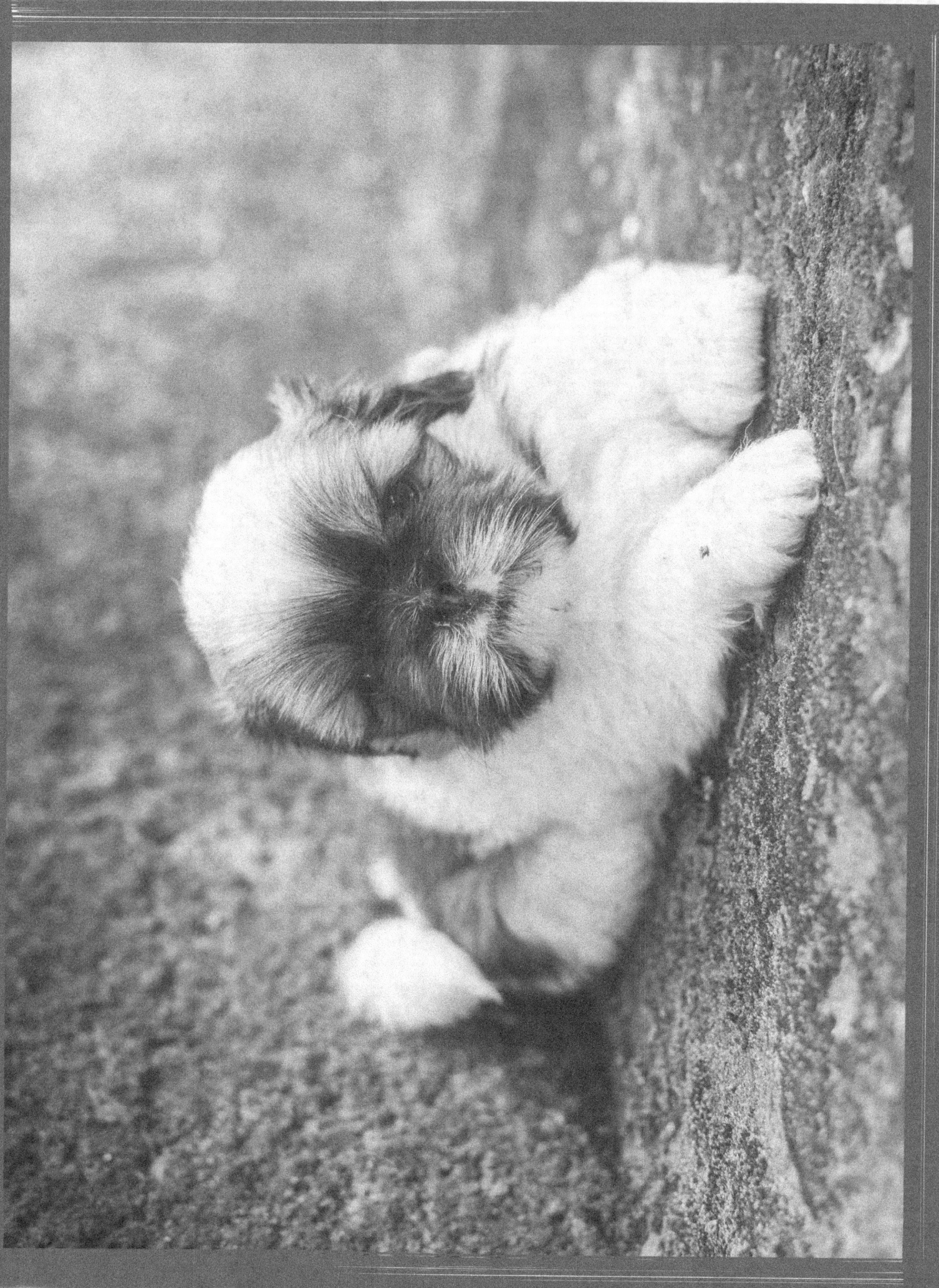

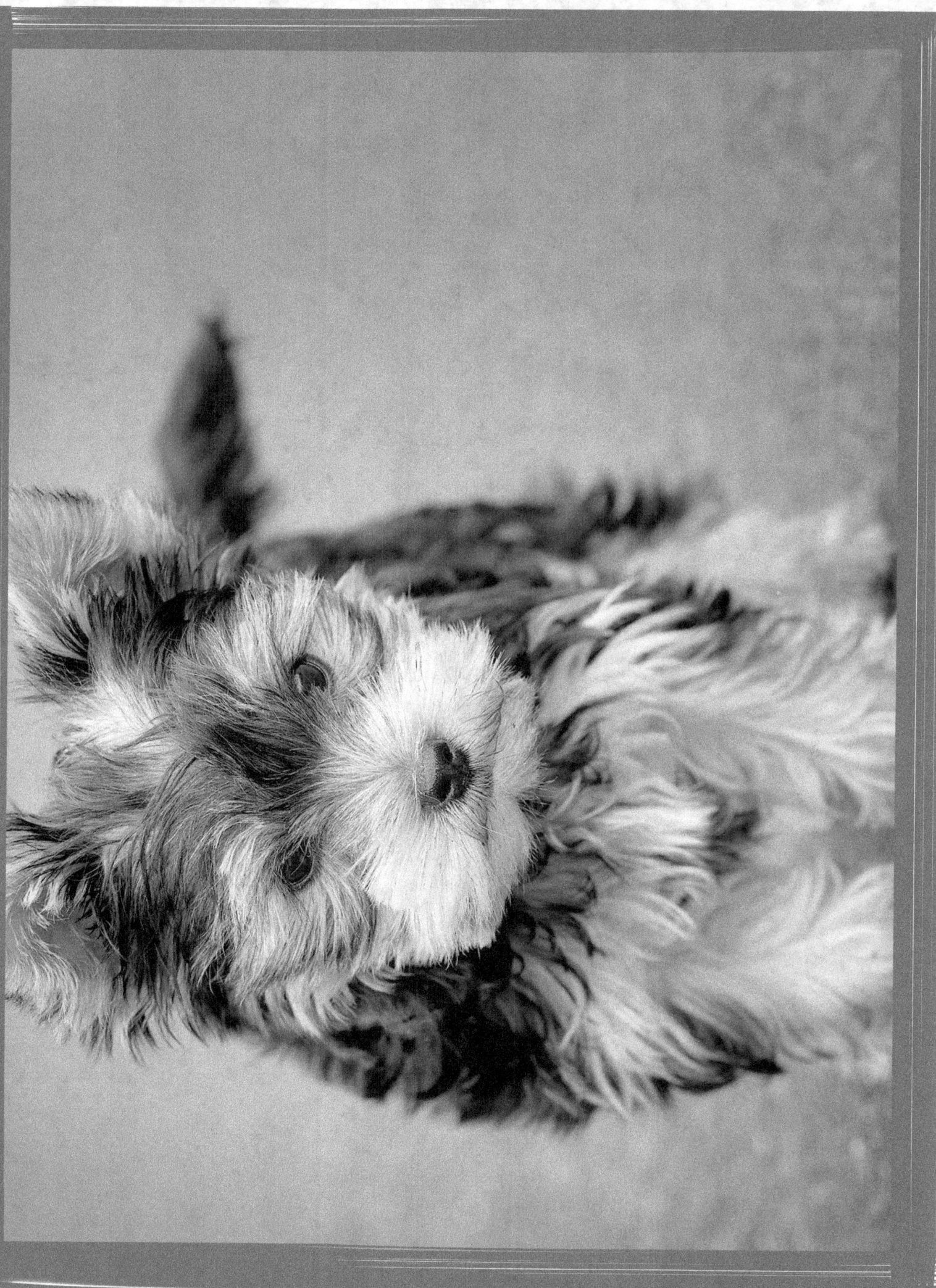

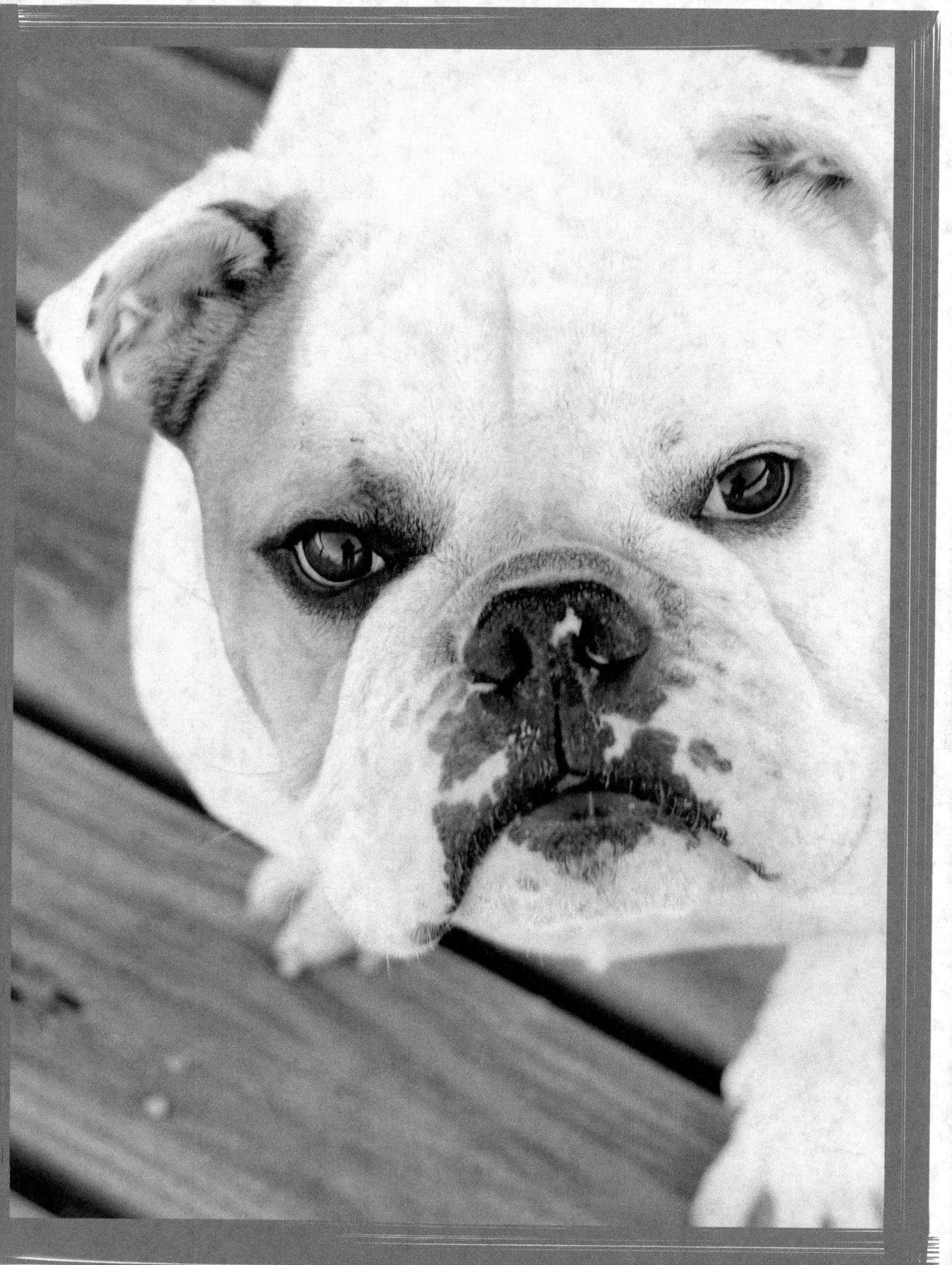

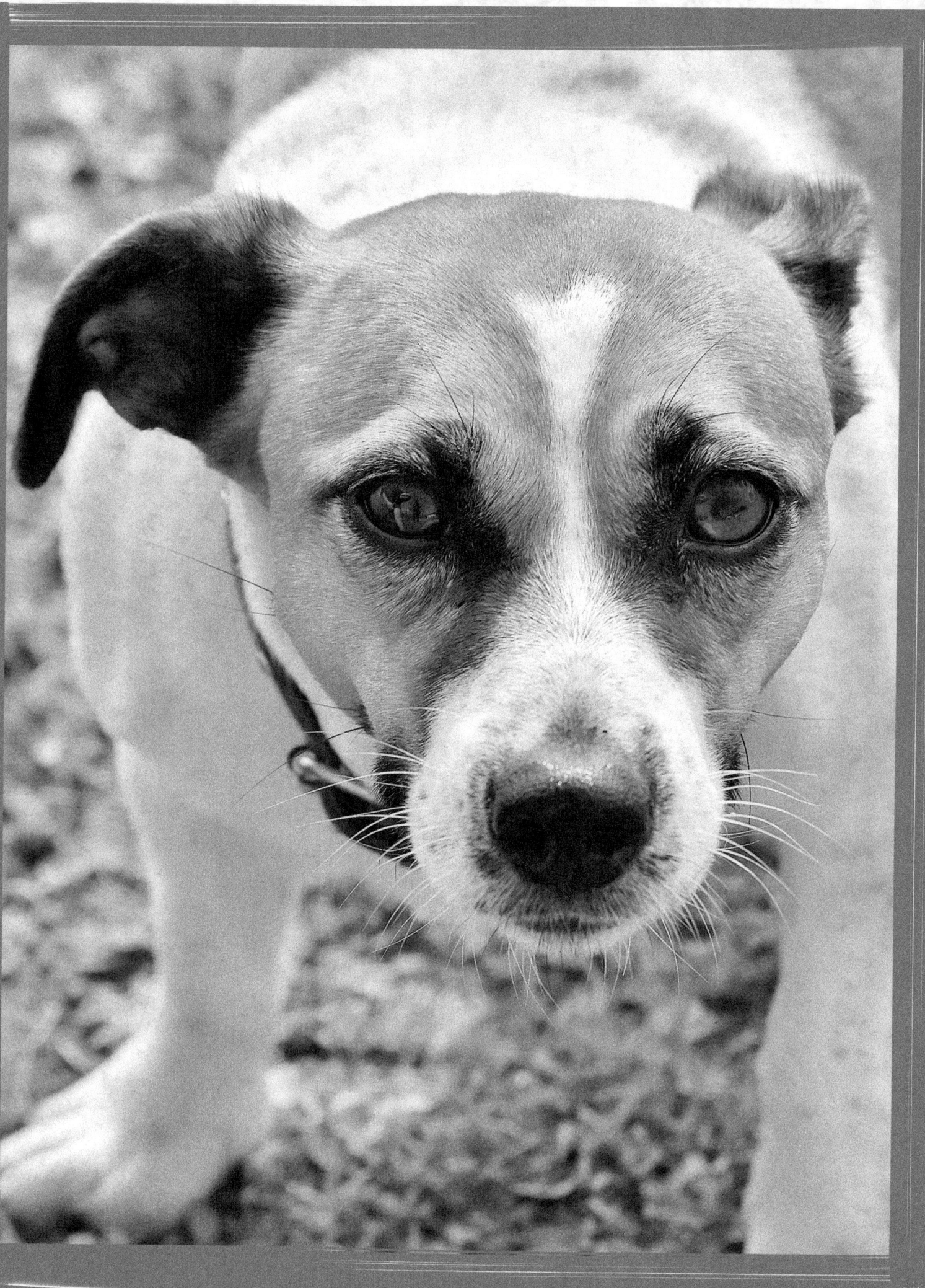

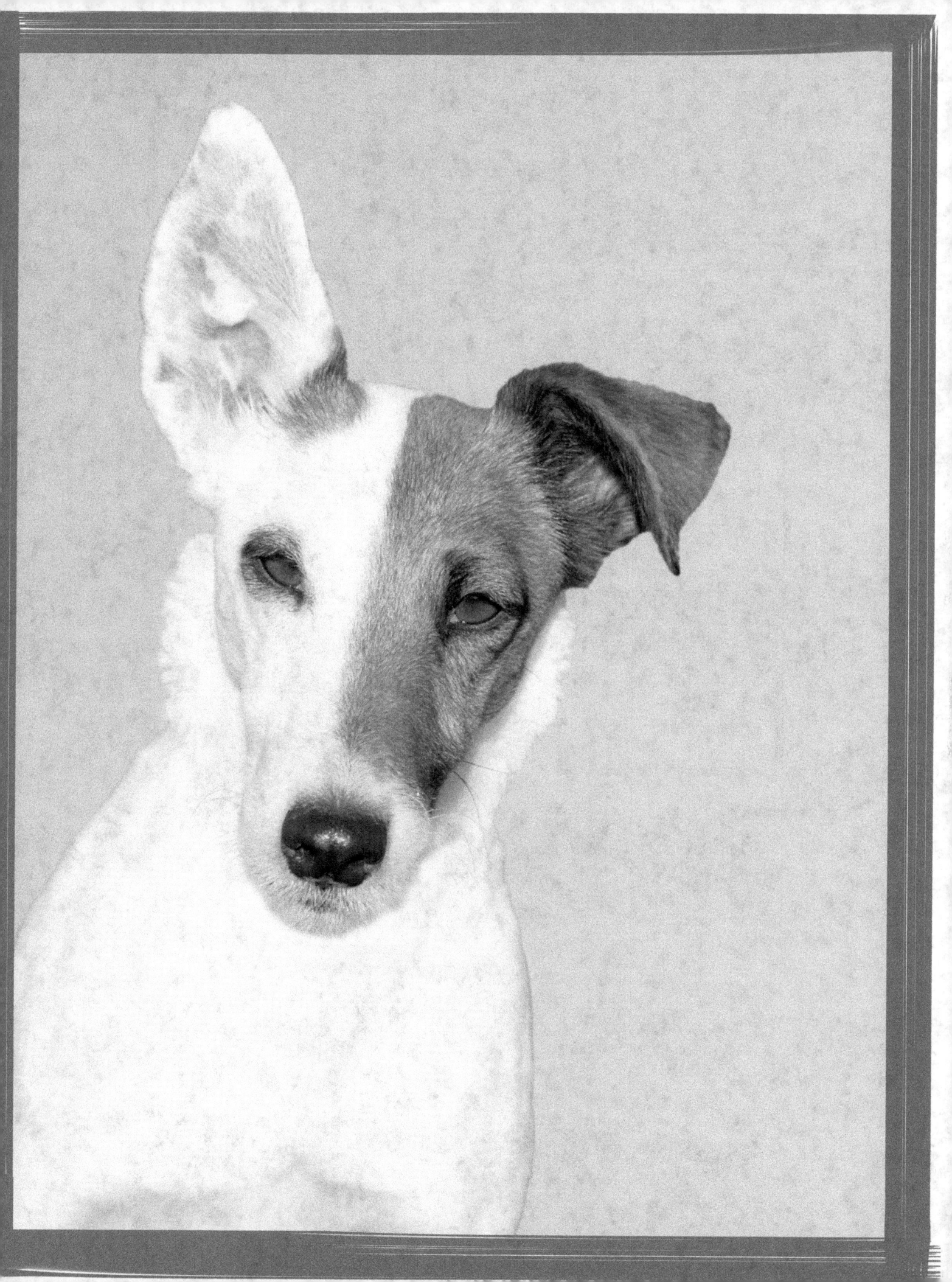

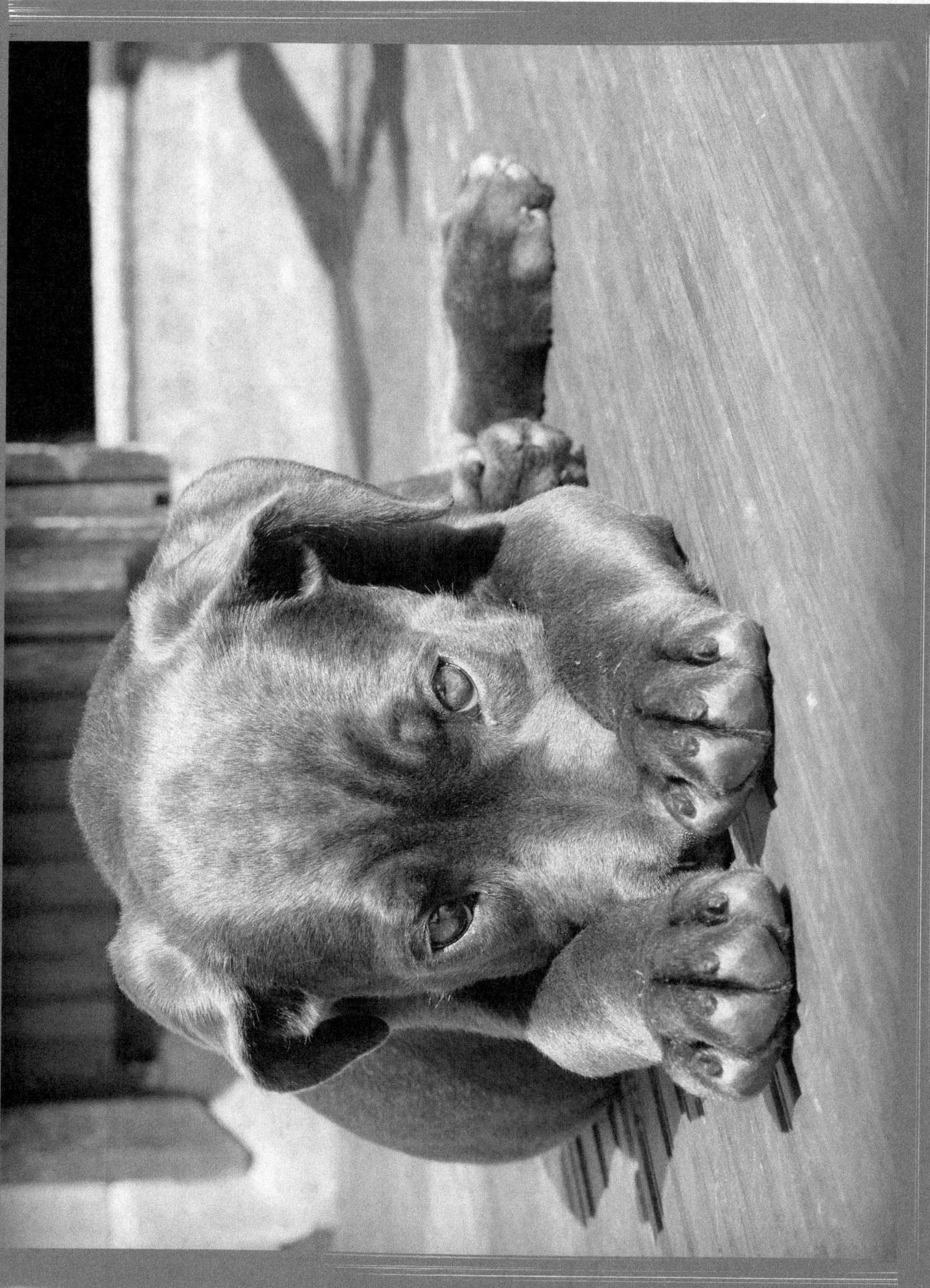

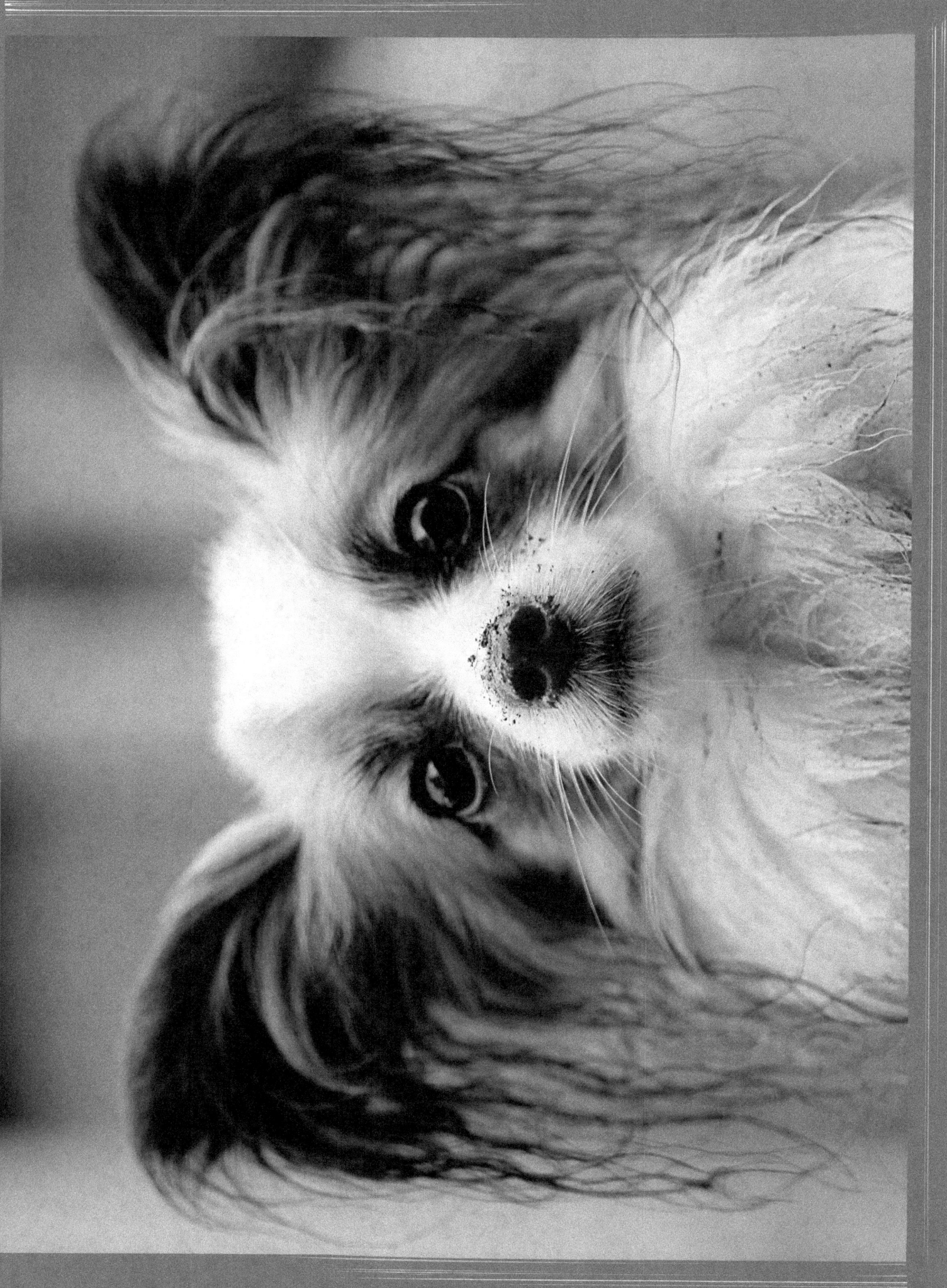

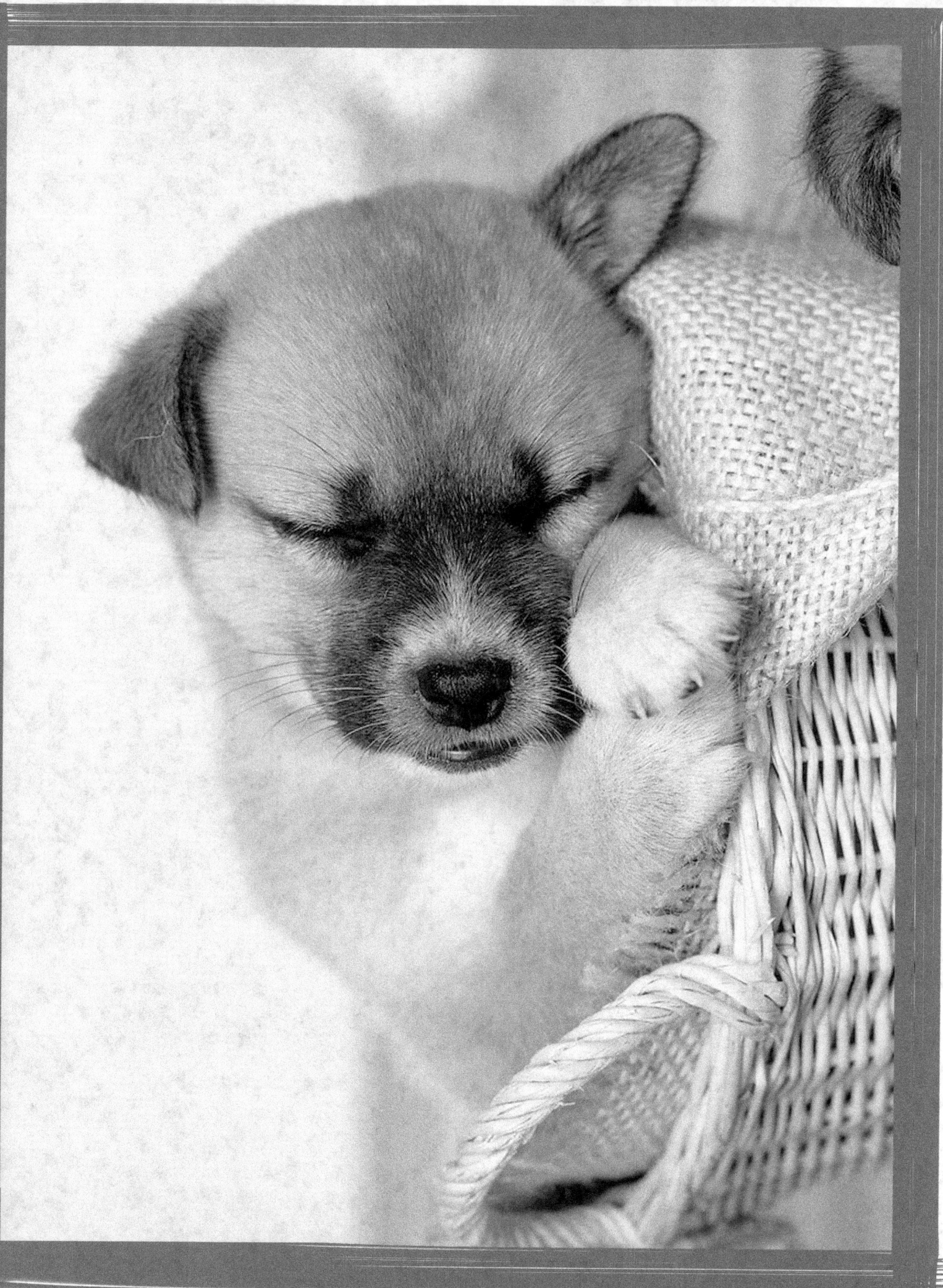

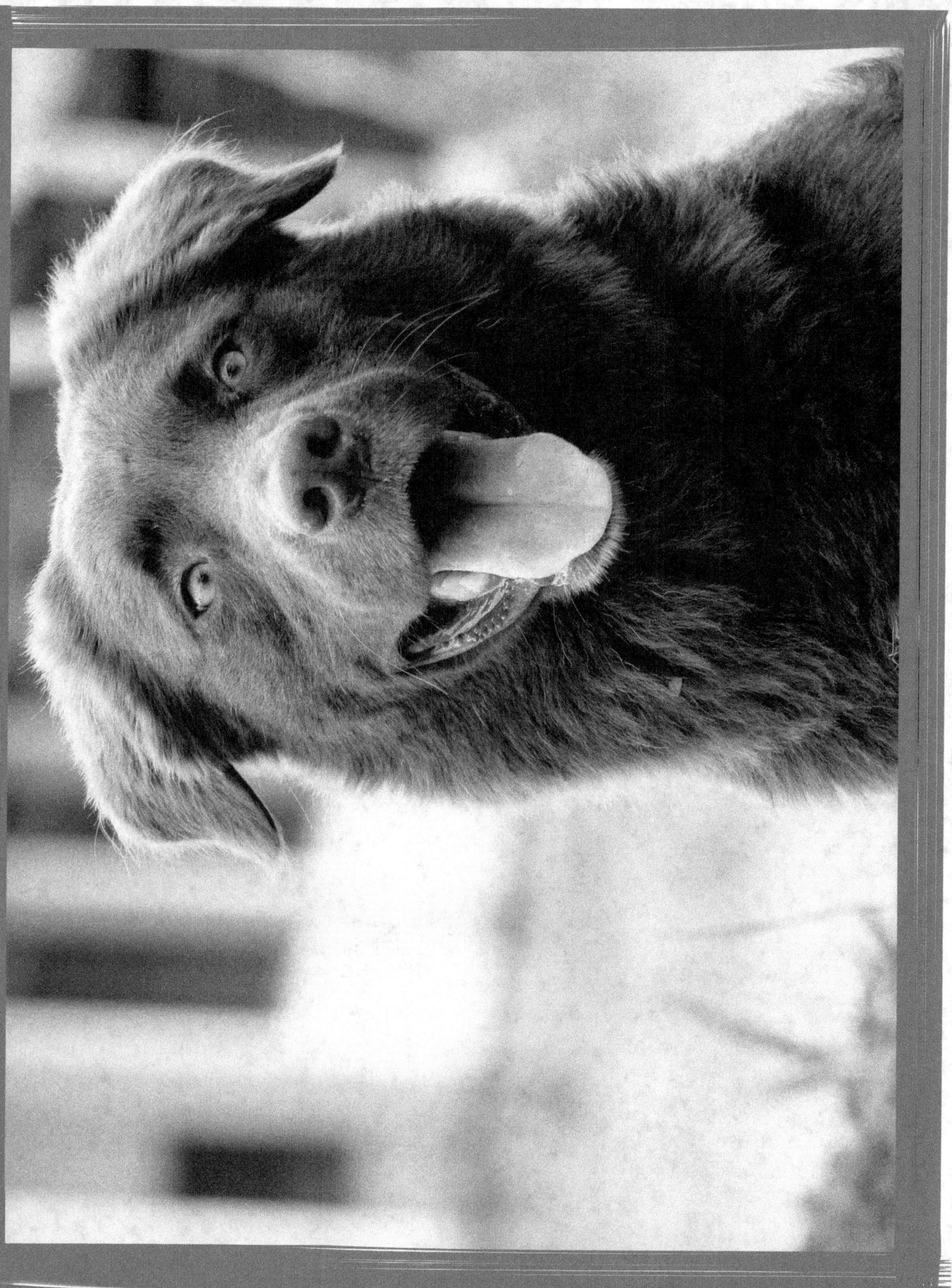

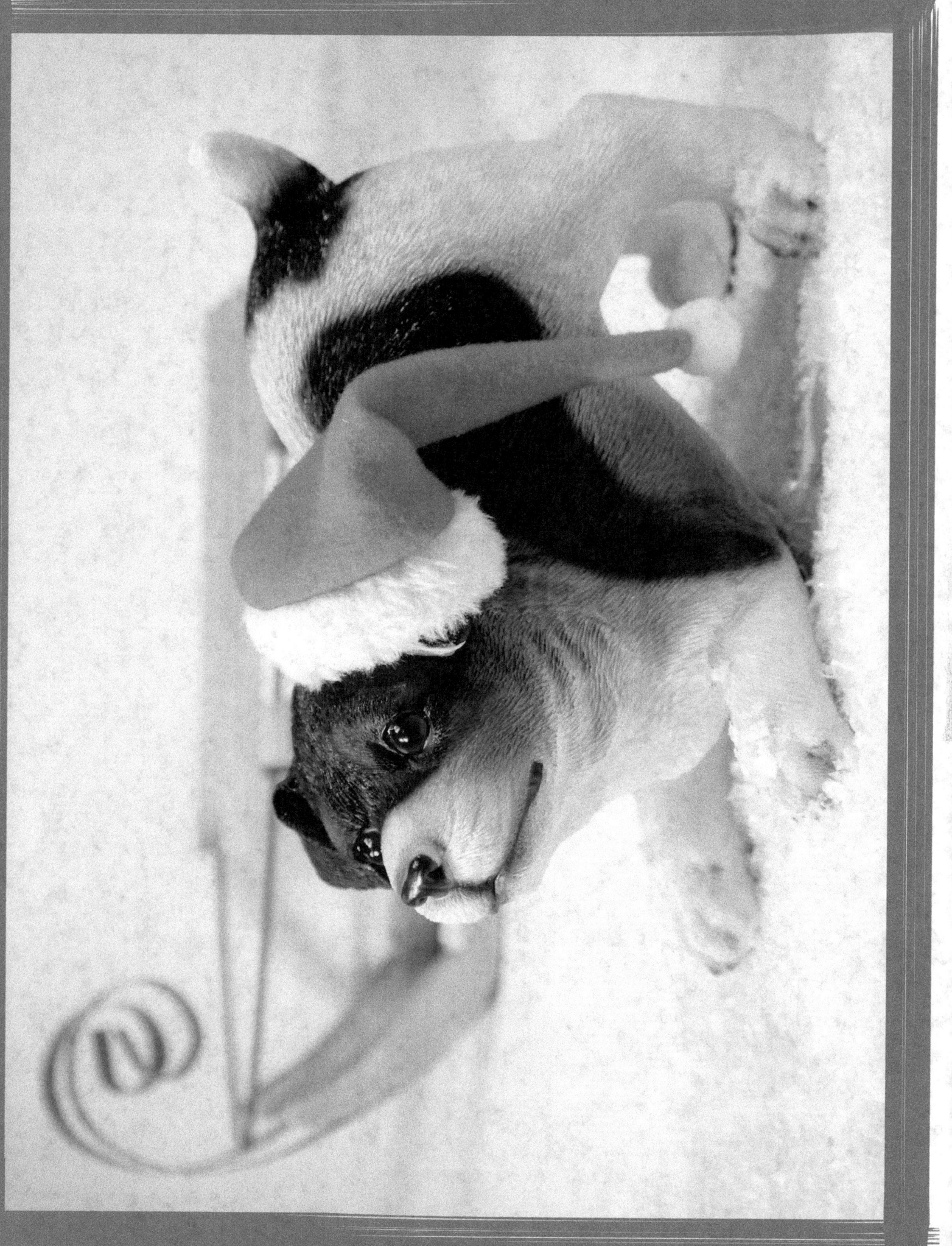

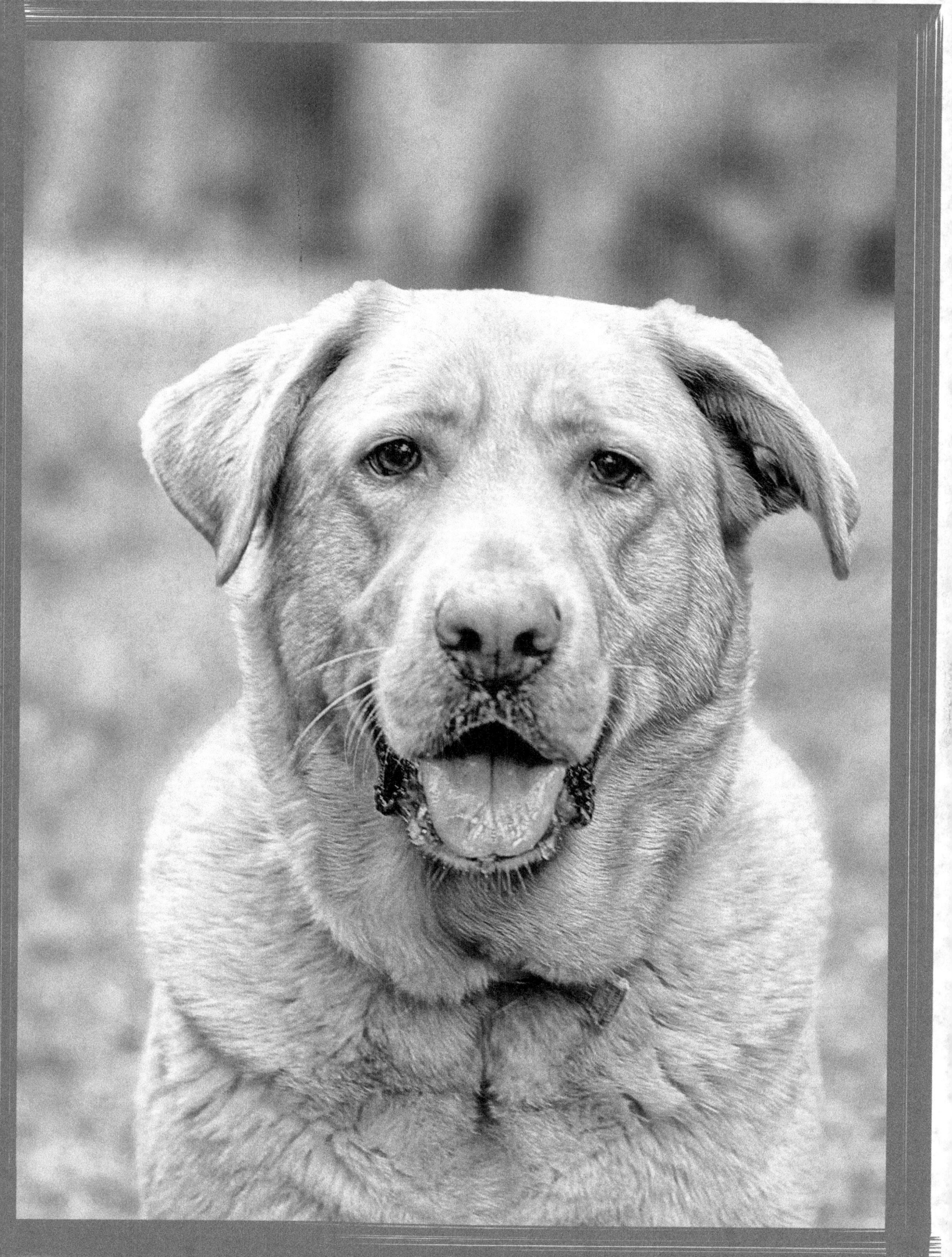

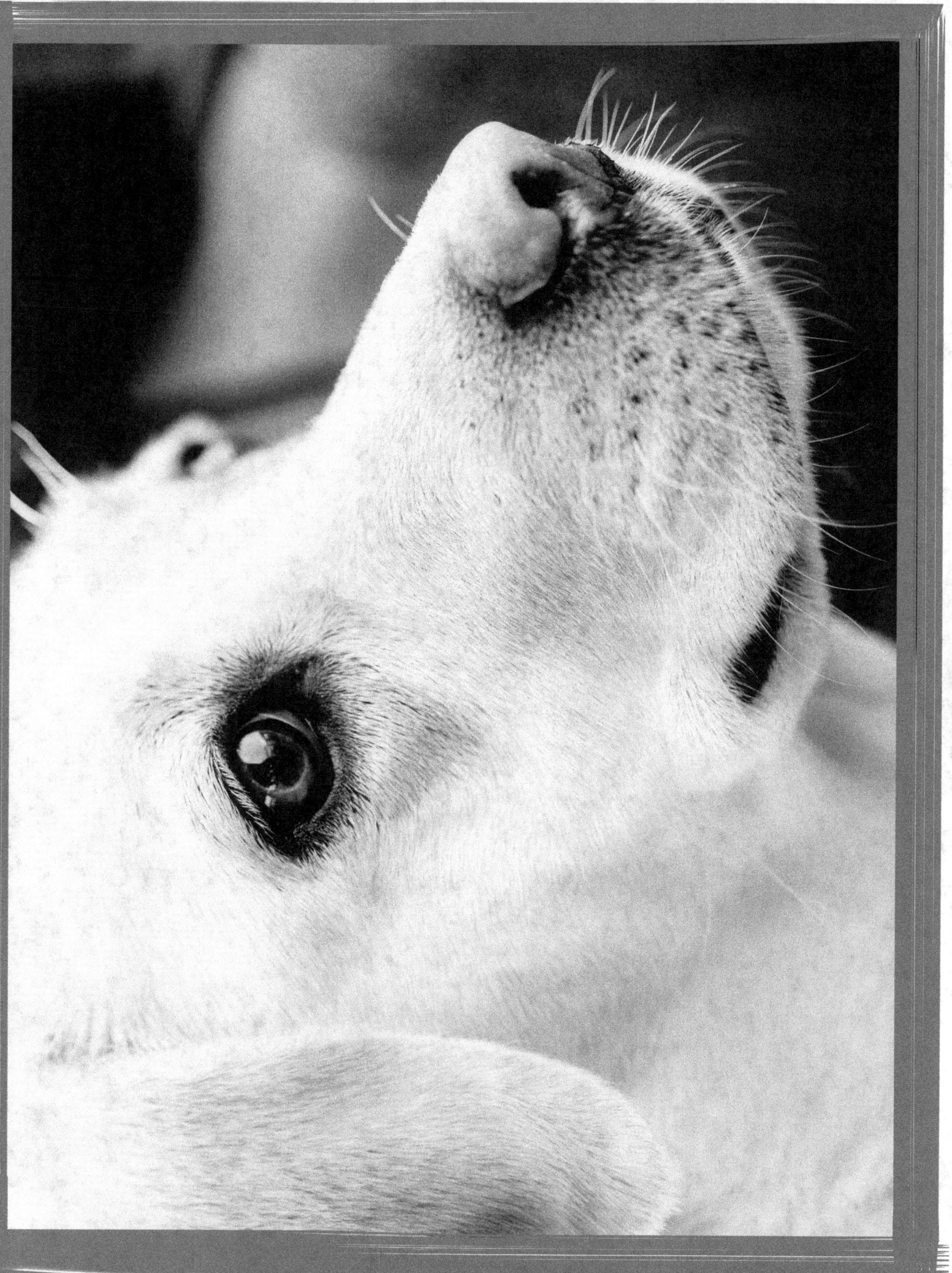

Your Amazon Review could really help us.
Thank you for your support.

Use Below Link to access review of this book.

http://bit.ly/dog_grayscale__review_5

Download PDF for this book at

http://bit.ly/dog_grayscale_c5

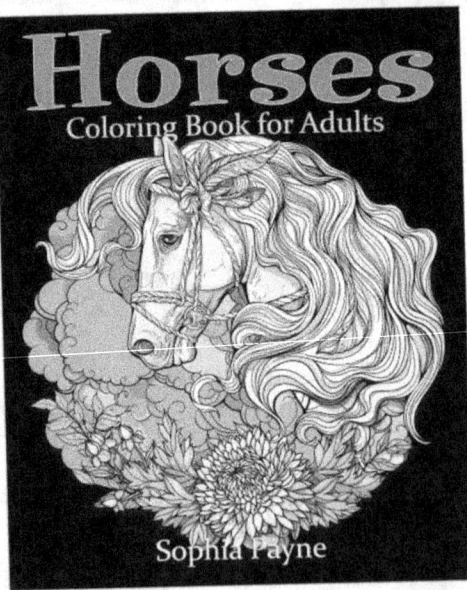
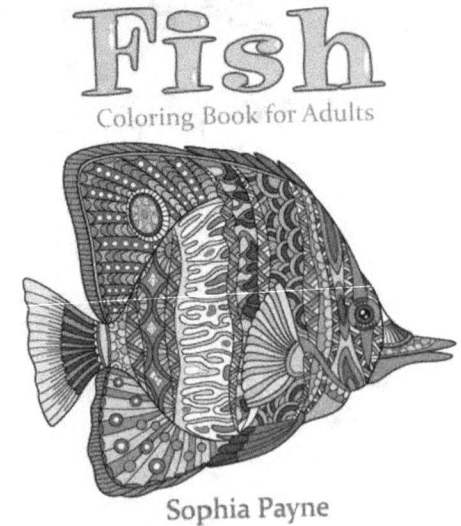

AND MORE...

At : bit.ly/v_art_coloring

Follow us on Facebook : V Art Studio

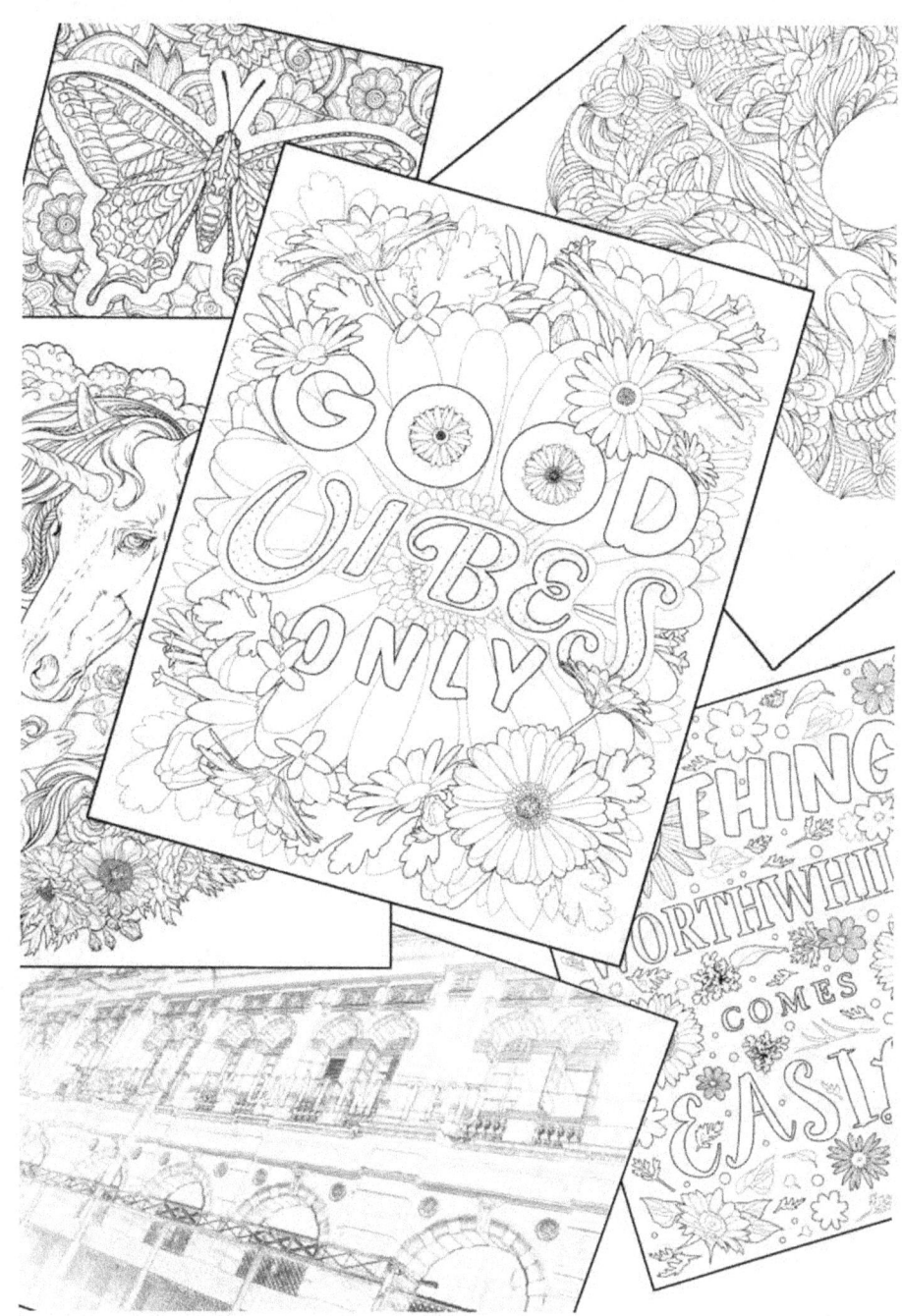

Join Us >> bit.ly/get_sample_free

- Get Free "Reviw Copies" of our New releases
- Exclusive offers and book giveaways
- More events from our community

Thank you